I. Values

When you meet someone on the street, you don't say — or even think —
"My, what a nice value pattern you have on today."

Get your eyes accustomed to looking at the world in black and white.

Malden Avenue 1946 by Dovie C. Polivka

Southern Living, May 1974, p. 168.

Baton Rouge Magazine, April 1981, p. 6.

Once upon a time, we had black and white cameras, and black and white film, and black and white photographs.

Nowadays, we look at a book and count the color plates; we watch TV, play with computers — it's all in color.

Find a black and white photograph. Look at the values.

Judi Betts has attained a national reputation for her transparent watercolor paintings. She combines eloquent design, strong technique and exciting colors to create award winning paintings. Of her work, Rex Brandt says, "I think that the reason Judi Betts's watercolors are so tremendously successful is that she knows how to make the paper work as well as the paint. And her work is authoritative because she paints her very own milieu with wide-eyed pleasure and wit, avoiding the exotic and melodramatic. Beyond all this, Judi seems to have an unusual ability to enjoy visual shapes rather than "thing" shapes, which gives her paintings a magical personality of their own." A member of many organizations including the National Watercolor Society, Watercolor USA Honor Society, Knickerbocker Artists and the Rocky Mountain National Watermedia Society, she is in demand as an instructor, lecturer, juror and judge. Judi has been recipient of both the Audubon Artists' Medal of Honor and their Silver Medal for Creative Aquarelle. She has also received the Business Community Award from the Rocky Mountain National Watermedia Society and the Mary Pleissner Memorial Award presented by the American Watercolor Society. The author, who resides in Baton Rouge, is represented in galleries and museums as well as private and corporate collections throughout the United States and Canada. Her work has appeared in various books and magazines including *Mastering Color & Design in Watercolor* (Watson-Guptill) by Christopher Schink and *Variations in Watercolor* (North Light) by Naomi Brotherton.

Joel Gardner, former assistant director of the Louisiana Division of the Arts, is currently director of the Perkins Center for the Arts in Moorestown, New Jersey. Throughout his adult life, he has earned his living with words: as a writer of everything from restaurant menus to magazine articles; as an editor of newsletters, books, and phamphlets; and as an interviewer of prominent persons in Southern California and South Louisiana.

Contents

This book was made possible only by the kindness of many artists, collectors and students. My appreciation to all of you, my friends, who over the years have taught, laughed and loved . . . and shared.

Special thanks are due Bob Gullic, Linda Schneider, Dave Gleason and, of course, Joel Gardner.

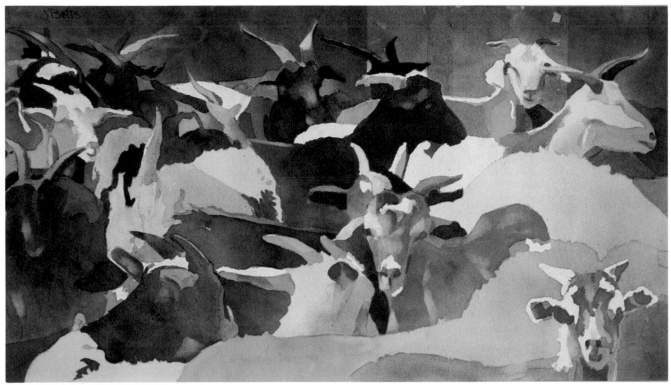

"RASCALS" watercolor 14" x 22" by Judi Betts, Award, San Diego Watercolor Society Exhibition 1983.

VALUE SCALE

1 Light 2 Light mid-tone 3 Dark mid-tone 4 Dark

You can learn values by cutting out black and white and gray paper
and assembling it into a visually recognizable scene or image.

C

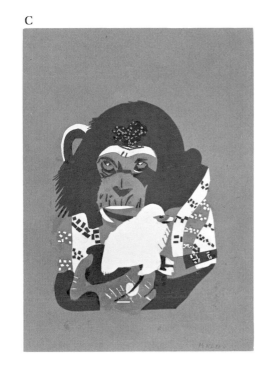

A

D

B

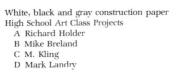

White, black and gray construction paper
High School Art Class Projects
 A Richard Holder
 B Mike Breland
 C M. Kling
 D Mark Landry

Paint using shapes.

The **mid-tones** — the grays — are the key to the whole.

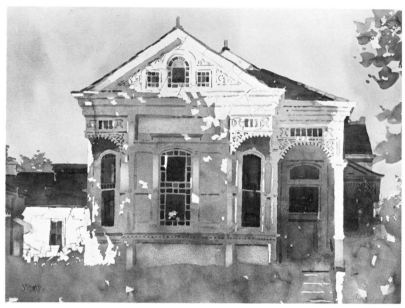

"CREOLE COTTAGE"
watercolor 22" x 30" by Judi Betts,
Collection of City National
Bank, Baton Rouge, Louisiana

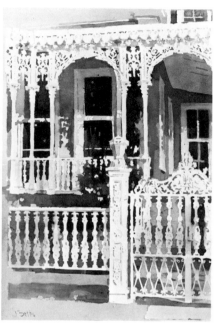

"LAGNAIPPE" watercolor 22" x 16"
by Judi Betts, Collection of Dr. John K. Griffith, Jr.,
Lake Charles, Louisiana

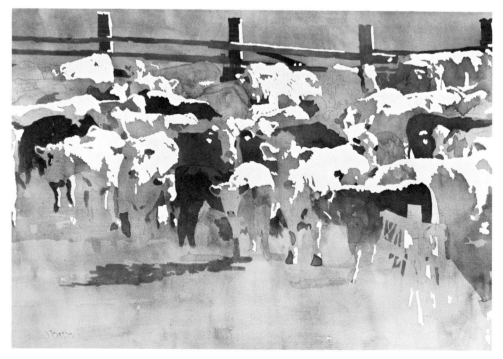

"EN MASSE" watercolor 22" x 30"
by Judi Betts, Exhibited in
Watercolor West, 1984

When I was at Indiana University, I won an award for the best portfolio by an art student.

And I painted for years.

It wasn't until I went to a workshop given by Barse Miller, who told me I didn't understand values because I couldn't see in black and white, that I started to think about painting in a different way.

You have to be able to see like this

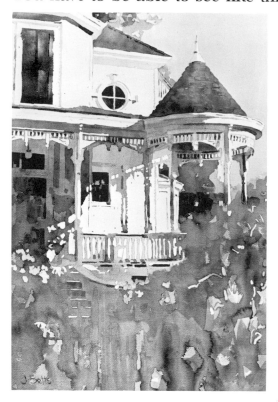

to paint like this.

"SOUTHERN SENTINEL" watercolor 22" x 16"
by Judi Betts
The Audubon Artists Silver Medal
for Creative Aquarelle 1982 -
New York, New York
Exhibited Rocky Mountain
National Watermedia Exhibition
1982 - Golden, Colorado

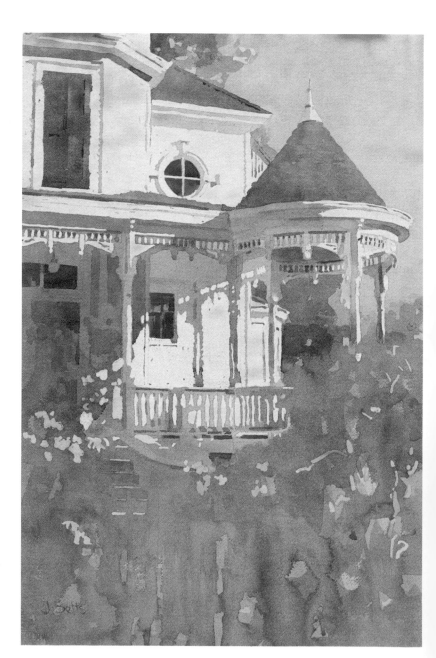

10

People worry so much about color in painting. Think about what you want to paint. Look at it. Does it have to be in color?

Look at highway signs, how dramatic they are.
You can read them quickly. They don't use words. They use universal symbols as simple instructions.

A lot of painters enjoy doing woodblocks or linoleum prints because it helps them to see in black and white.

Doing a woodblock, you cut away the light parts, and use the negative shapes—instead of the positive, to which most of us are accustomed.

Try working with white acrylic paint on a black page.

How many people can see the beach in **black** and white?

You don't think of the ocean, the sky, bikinis and umbrellas, unless you think of color.

II. Limited Color

The color you see when you look at something is *local* color — a yellow sweater, a **red** stop sign, a blue sky on a sunny day.

Artists often think in terms of limited color.

To think about limited color, you have to think about *contrasts*.

It's *hard* to think about life or painting as extremes. It helps
if you think of contrasts.

yin	and	yang
male	and	female
night	and	day
winter	and	summer
tall	and	short
rough	and	smooth
happy	and	sad
old	and	young
warm	and	cool

If you have a warm color and a cool color, you have the basics.
You really don't need anything else.

Limited color is the artist's *intentional* choice to restrict
the palette.

For example, use cobalt blue (cool) and burnt sienna (warm).

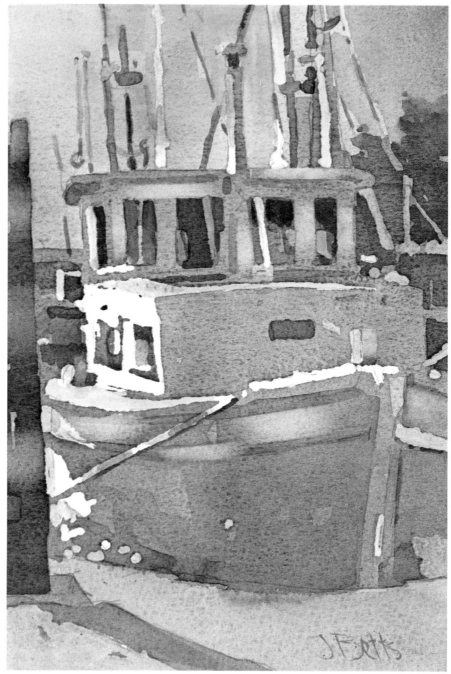

Watercolor 6" x 9"

Because of the contrasts, you can create something exciting.

Try it.

Mix a small amount of the two colors together. Using very little water mix until you get the darkest dark, till it's almost black.

As you mix, notice the value range of the various grays.
Grays that have more blue are cool grays.
Those with more red are warm.

Experiment some more. Notice the intensity of the color as it comes straight from the tube. Now add a little water and notice that the color becomes lighter. Do this with the warm color and cool color separately.

Look at a tree trunk. Is it a warm gray or a cool gray?

How warm?

How cool?

Look at pebbles in a gravel driveway. Shells on a beach.

"MISTY" Transparent acrylic watercolor on paper 21 x 29½" by Al Brouillette AWS ANA; Award, Rocky Mountain National Watermedia Exhibition; Award, National Watercolor Society

"The subject is obviously a figure.
The reason for doing the
painting is the interplay of
cool neutral grays working
against fresh, warm tube colors.
Reality transformed into
artistic terms."

— AL BROUILLETTE

Can your eyes identify colors by

cool

warm

cool
dark

warm
light midtone

warm
midtone

?

One shadow can be cooler than another. A day, a face, hair — all of those can be gray. Can you see them in relation to something else?

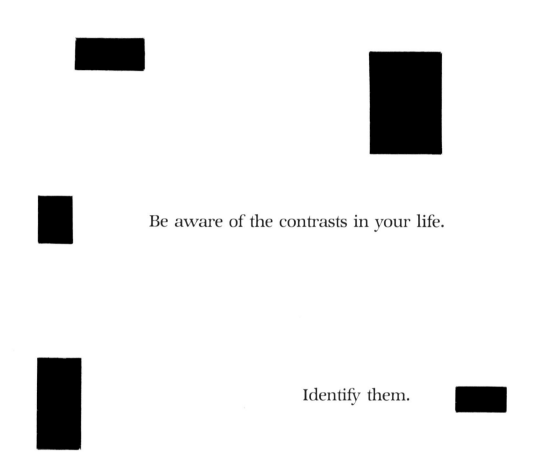

Be aware of the contrasts in your life.

Identify them.

Put them in a painting.

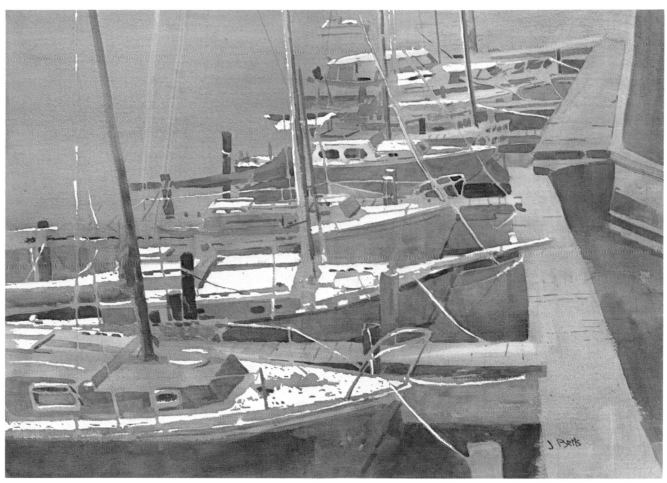

"MOOD INDIGO" watercolor 22" x 27" by Judi Betts, Award, Western Federation of Watercolor Societies Exhibition, San Antonio, Texas; Award, Hudson Valley Art Association, White Plains, New York.

III. Contrasts

Have you ever stood next to a football or basketball player and felt tiny ?
Do you remember how big people seemed to you when you were a child?
Stand next to a shorter person. Don't you feel tall now?

Be aware of the contrasts in life.

To make woods magnificent, a small figure in their midst will give a sense of greater bigness.

We identify flowers in a field by their size as well as by the contrast of warm and cool colors.

In drawing a building, notice that the smaller you make the windows, the bigger the building will seem.

Another contrast is opaque vs. transparent.

Many beginning painters complain that their works seem muddy. But muddy areas can be used to bring out color. That's contrast.

A sky will appear more luminous if you paint opaque shapes over part of it. See how an opaque shape — a branch against a sky — makes it more transparent.

A stained-glass window is all the more luminous because of the strips of metal that define its areas.

Two-color painting can be especially exciting. Think of all the colors you can mix, the warm and cool contrasts you can create.

Near and Far

Background

FOREGROUND

Overlap is one key to depth. Perspective is another.

Linear Perspective

distance

in the

diminishing

of parallel lines

is the emergence

Linear Perspective

AN EXAMPLE OF

Atmospheric Perspective

Warm colors come forward;

cool colors recede.

A red jacket becomes less intense in the
distance.

Gradation is a very *subtle* contrast, yet it can give a
feeling of PUSH and PULL

and a slight tilting of the

picture plane.

To me, gradation in painting is like very minor tone changes in loud
and soft in music.

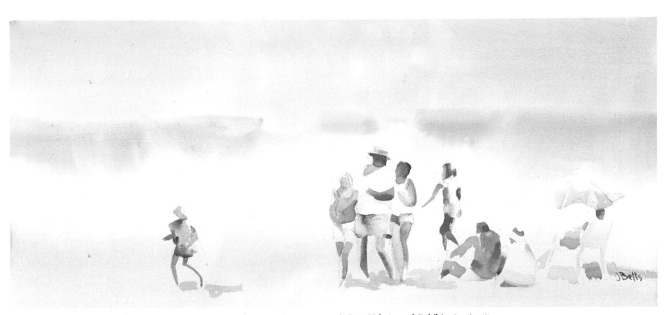

"BEACH BOYS" watercolor 16" x 30" by Judi Betts, Award, Texas Fine Arts Association, 68th Annual Exhibit, Austin, Texas.

IV. Color

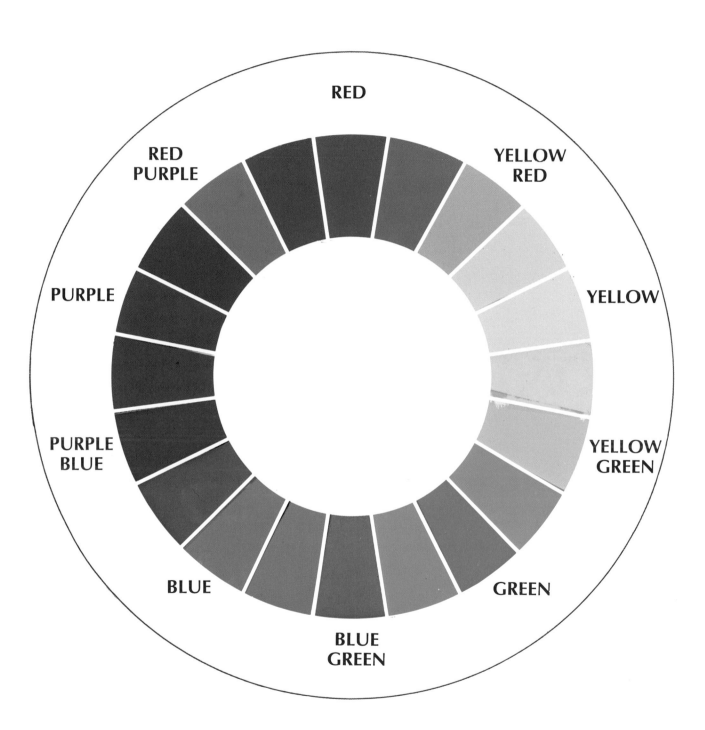

See a color by relation to what's around it. You must see the colors in relation to one another before you can think about painting.

Know the complements . . . The adjacents . . . The discords.

Be aware of their use in nature.

There must be a **dominance**. Look for it!

At Christmas, equal use of red and green isn't as pleasing as the dominance of one over the other.

"He who wishes to become a master of color must see, feel, and experience each individual color in its many endless combinations with all other colors."

Johannes Itten, in *The Elements of Color.*

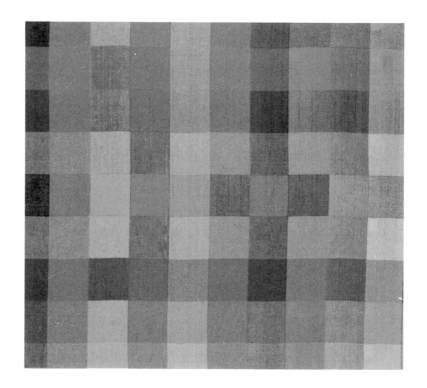

HAVE YOU EVER TRIED TO PAINT A PLAID DESIGN?

Play with color. Get some different colored strips of Banner paper
and cut them up. Play with them. Put them together in an abstract design.

SEEING IS SUCH A PRIVILEGE.
WHO NOTICES THE WAY THE SCREECH
OF A GULL LOOKS, THE LOOK OF A GALE, THE SIGHT
OF SOME FRAGRANCE? A RED APPLE ISN'T
RED, NOR THE LEMON YELLOW. THE SKY IS SELDOM BLUE,
ONLY WHEN IT ISN'T. EVERYTHING IS COLOR.
THE SLIGHTEST NUANCE HAS ANOTHER PRECISE
MEANING. COLOR IS A LANGUAGE OF THE POETS.
IT IS ASTONISHINGLY LOVELY. TO SPEAK IT IS
A PRIVILEGE. ANYTHING CAN BE ANY COLOR AT
ANY TIME DEPENDING ON WHAT COLOR EVERYTHING
ELSE IS AT THE TIME.

KEITH CROWN

QUOTATION FROM THE CATALOG OF THE LONG BEACH MUSEUM OF ART EXHIBIT 1966.

How many browns can you find?

How many blues?

Have you ever played with color before? Have you ever made a bouquet of wildflowers? Matched clothes? Painted the rooms of a house?

Make some abstract designs.

Do warm dominants. Play with them. Now cool dominants.

Do you enjoy color? Do you enjoy walking into a fabric shop or paint store looking at the colors of the things for sale? Or seeing how towels are stacked or arranged in displays at a department store?

Can you enjoy an abstract painting without knowing what it is?

Look at the sections on this pattern. Which do you like best?

How do the colors make you feel?

Paint 2 o'clock yesterday . . . with no drawing. No objectivity.

In *thinking* about 2 o'clock yesterday, what colors do you see?

Paint the *sound* of your pet.

Your child.

A rock.

Without any subject matter.

You don't have to tell anyone what it was you were thinking.

Paint

a solemn occasion.

the way your favorite food smells.

Use any size brush. Paint horizontal or vertical.

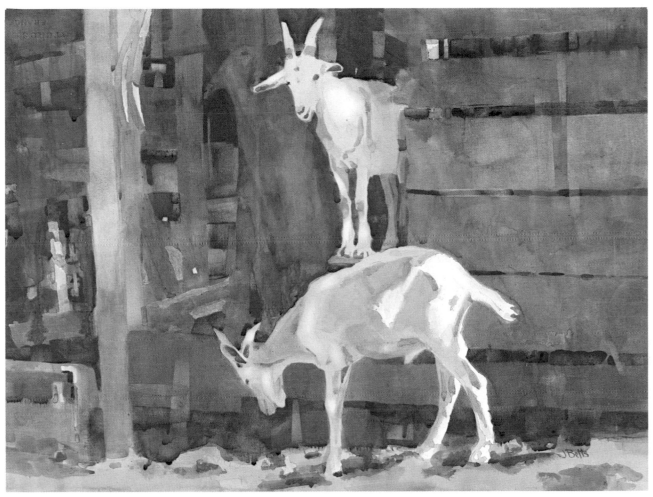

"BUCKSHOT AND SPARKPLUG" watercolor 22" x 30" by Judi Betts, exhibited Southwestern Watercolor Society, Dallas, Texas and Kentucky Watercolor Society, Louisville, Kentucky.

Now mix some colors. Look at a color. Is it bright? What is it? Name it.

What would you mix with it to get tan? Another color?

Color has to do with observation. The relationship of color is in the amount.

Take pleasure in seeing the amount of each color. Be aware in everything you see of the amount of color. Take a walk and look at grass and trees and bushes. How much green is in each?

Learn what each color looks like. Be able to recognize burnt sienna, rose madder, or Antwerp blue. Know each color as well as you know what an apple tastes like, or cinnamon, not just by blue or red or yellow, but by

Winsor yellow, or

aureolin yellow, or

yellow ochre, or

cadmium yellow.

Can you describe them to someone else?

Which yellow would a painter consider to be like the fruit lemon

the center of a fried egg

mustard?

Can you name four varieties of each primary color as they come from the tube?

Become aware of the infinite varieties of color in nature. Millard Sheets had students mix 52 greens in a class. He recommends doing a color chord a day.

V. Creativity

Nothing in this world is as powerful as an idea whose time has come.
— VICTOR HUGO

Creativity is relating the normally unrelated and seeing things in unusual ways.

95 percent of each day is habitual; if you create you leave the familiar.
— DORIS WHITE

To walk through a door and into a room and be completely surprised is so exciting! — in architecture and decor you see something unexpected.

There is no earthly substitute for the creative vision, seen personally & externally expressed.

— morton leeds

Creativity is using things for what they're not intended:

Using a table runner as a stole . . .

Using umbrella stands and planters as waste baskets.

Creativity is surprise:

A book with an unusual ending

A painting that's not rectangular

(Doris White says we should do more square paintings)

A caboose for a house.

Mr. and Mrs. Tom Morris
and
ABC NBC CBS
invite you to the wedding
of
Lady Di and Prince Charles
the twenty-ninth day of July
1981
one to six o'clock a.m.
2000 Country Club Drive
Medford, Oregon

champagne and wedding cake
will be served

rsvp 772·5306 no gifts

Judy Morris, Artist
Medford, Oregon

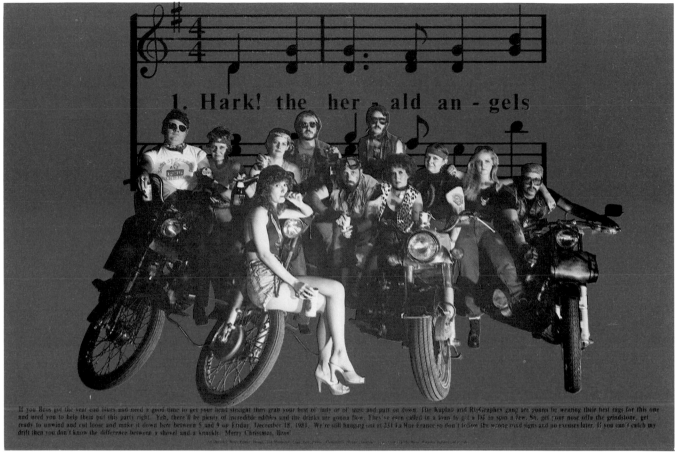

Concept and design by RioGraphex, Lafayette, Louisiana

Terry and Kerry Palmer (top row) identical twins who are now professional graphic artists, were art students of mine in high school many years ago.

and our regret mailed to them.

TWIN Bros:

Wet and Wild! One more **Winner** from **NUMBER ONE**. Man, we **Jammers** were gonna toot 'n shoot on over fer Octane Boosters at your TURBOCHARGER. In fact we were figurin' on a **Tatoo** with the decorative **HARDWARE** and **GOOD TIMES** (cuz ya never know whats under the next **CHROME** cover) — in fact we hear you're the last word on **FRONT ENDS**, **HARDTAILS**, miscellaneous chrome things and Black Underwear. But we were **HARLEY** hopping on our **Fenders Tanks & PIPES** with goggles, glasses & gloves when the **RADAR RECEIVER** picked up an ELIMINATOR. TWIN Bros on December 18 we gotta **choice** — Necessities or hittin' lots of **LEATHER** our rear connections flyin' over **SISSY BARS, FOOTPEGS & FLOORBOARDS**. Man — we wish you another **TRIUMPH**

Up **Harley** Up **Davidson** on Kawasaki and **Suzuki**!

Up **TRIUMPH** Up **YAMAHA** on **HONDA** and Blitzen!

and to all a Merry Christmas

Judi & Tom

—and patch us into your next **SPORTSTER** 'cuz it's always fun **Working with the best.**

Don't make a quick judgment. Experience something new from inside and all around before you judge it.

Invent

a color a title

a new way to go home

Break away from old habits.

We reflect what we eat, and a painting is a mirror of us. Have you tried any different kinds of food lately?

Being inquisitive has to do with learning and creativity.

Creativity is new ways of seeing the same thing.

Ink drawing 14" x 12" by James Schexnaydre, Gonzales, Louisiana, 1981 (High school class assignment)

In this painting, for example: I'd painted lots of groups of cattle
but the patterns of light here were different from
any I'd seen before.

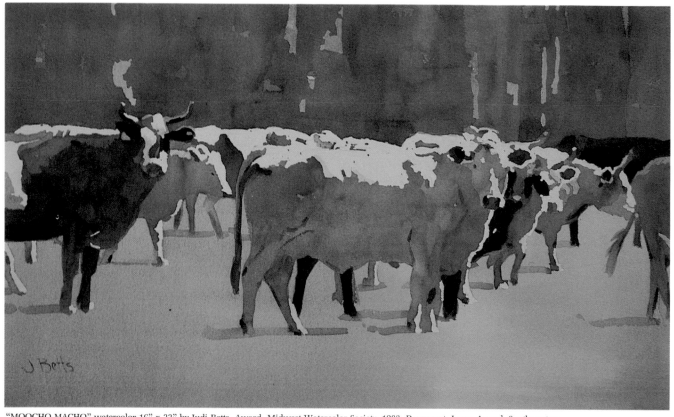

"MOOCHO MACHO" watercolor 16" x 22" by Judi Betts, Award, Midwest Watercolor Society, 1983, Davenport, Iowa; Award, Southwestern
Watercolor Society, 1982, Dallas, Texas; Award, Knickerbocker Artists, 1983, New York, New York

A painter whose work we feel is creative
may see the usual

in an unusual way.

Look for variety . . . You seldom see an exact repeat of anything.
I have an identical twin sister (who is also left-handed),
but we're not *exactly* alike.

See different times of day

temperatures

climates

sunny days

hot and cold days.

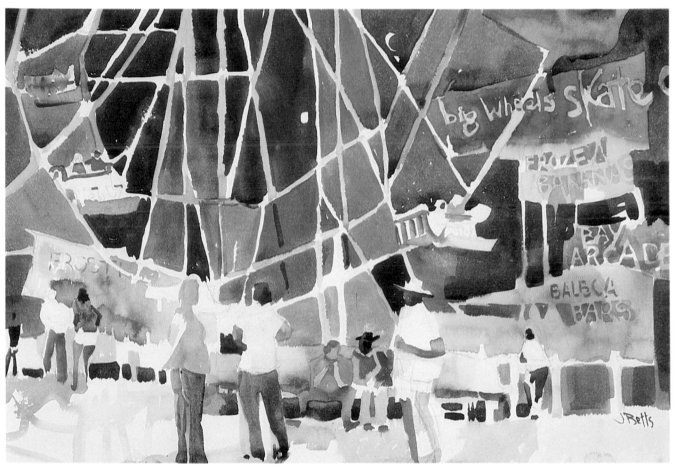

"BIG WHEELS" watercolor 16" x 22" by Judi Betts, Collection of Dr. Jed Morris, Baton Rouge, Louisiana

Look at a night painting. If you do a night painting, with streets, buildings,
people, cars, you'll find all sorts of light sources: from
within, from headlights, from street lights, from moonlight.

Because of the light sources, you can be a little more frivolous and creative
with the patterns of light.

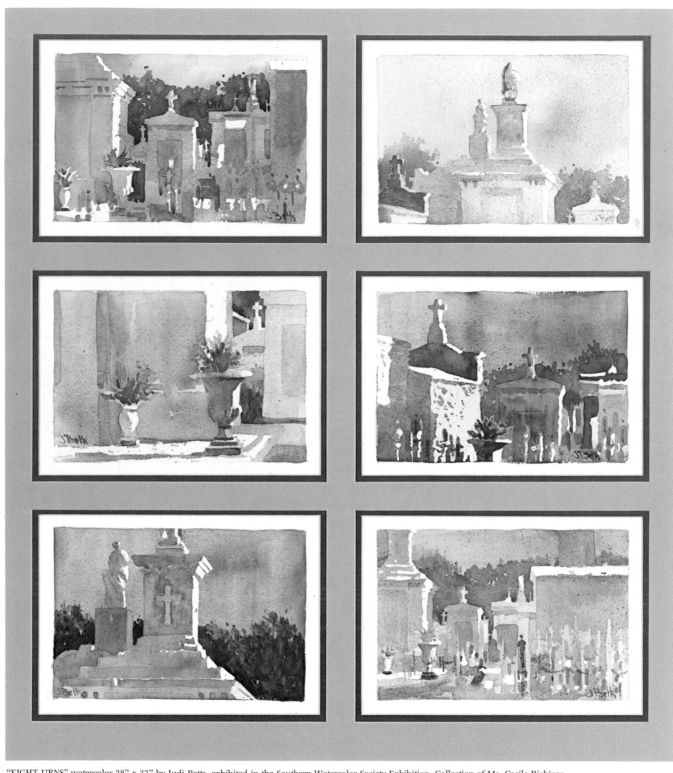

"EIGHT URNS" watercolor 28" x 32" by Judi Betts, exhibited in the Southern Watercolor Society Exhibition, Collection of Ms. Cecile Richinse, Baton Rouge, Louisiana.

This painting involved found objects with an intriguing pattern of light and shadow. It was fun working on the total concept.

BAND CONCERT
Concert Band
Symphonic Band
Jazz Ensemble

ART EXHIBIT

Thurs. April 29, 1982
7:30 p.m.
East Ascension High School Gym
Donation $2.00

Duane LeBlanc

For a high school art poster project
my students were given pre-printed posters.
Each chose a creative way
to "entertain" the viewer.

BAND CONCERT
Concert Band
Symphonic Band
Jazz Ensemble

ART EXHIBIT

Thurs. April 29, 1982
7:30 p.m.
East Ascension High School Gym
Donation $2.00

James Schexnaydre

BAND CONCERT
Concert Band
Symphonic Band
Jazz Ensemble

ART EXHIBIT

Thurs. April 29, 1982
7:30 p.m.
East Ascension High School Gym
Donation $2.00

Darren Truax

East Ascension High School students, Gonzales, Louisiana

1979 Calendar 5½" x 4"
Designed and printed by
Janet Hilford
Newport Beach, California

Creativity is a different perspective.

Lying on your back and looking up.

An entirely different viewpoint:

Inside a beer can looking out.

Thus for the apprentice as a painter or as a composer the primary rule is to follow purely the pleasure of his eyes or ears in the colors or sounds he will be responsible for; to respect this pleasure, and pay total attention to it; at every instant to produce nothing but what the senses are fully pleased with. For the creativity of the spirit, in its longing for beauty, passes through the senses, and is first vigilant in them, in a fragile way.

— JACQUES MARITAIN in *Creative Intuition in Art and Poetry.*

To create one's own world in any of the arts takes courage.

DESIGN

"Good design is a great combination of common sense, unusual imagination, clarity of purpose — with a prerequisite knowledge of structure, values, color, aesthetic insight and a deep reverence for the love of life." (deep love for the meaning of life)

Millard Sheets gave us this definition of design at his class at Southern Oregon State College, Ashland, Oregon, summer of 1979.

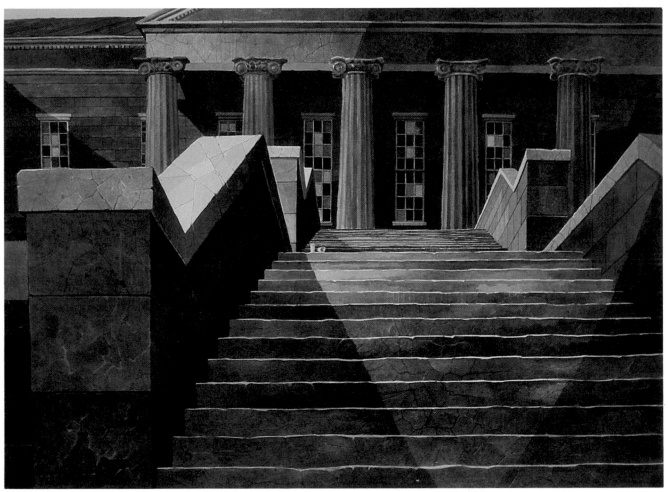

"COURTHOUSE CLIMB" watercolor 22" x 30" Rolland Golden, N.W.S., A.W.S.

In "Courthouse Climb" I used severe perspective to create a forceful composition and the illusion of looking up. The coloration on the steps is totally mine, introduced to help break the monotony of horizontal lines and create further interest without disturbing the concept.

— ROLLAND GOLDEN

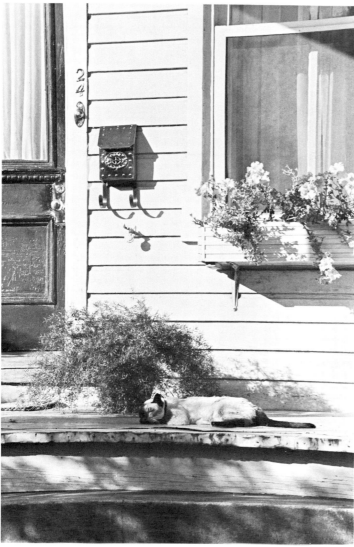

"SOUTH BATTERY RESTING PLACE" 9½" x 6¼" photograph, 1983, by Vicki Pullen,
Chairman, Art Department, Columbia College, Columbia,
South Carolina.

When a photographer uses a camera, he or she will set up
each shot: Move over here. Get closer.

That photographer is subconsciously creating a better design.

The combination of the conscious and the unconscious will lead to
something more majestic.

VI. Drawing

In painting, having drawn a great deal is an important tool. This can
be formal training or simply filling sketchbooks.

Millard Sheets says that everyone should draw something new every day.

Even if you don't have the pencil, pen, brush or stick in your hand,

keep alert! and look!

There's always something new.

A pattern on cement.

The way the sun hits a ceiling fan.

This drawing was made by Millard Sheets, author of "Your Drawing Is A Measure of Your Mind," on his recent trip to India. He said it is a small sketch of what he hopes to execute as a large painting.

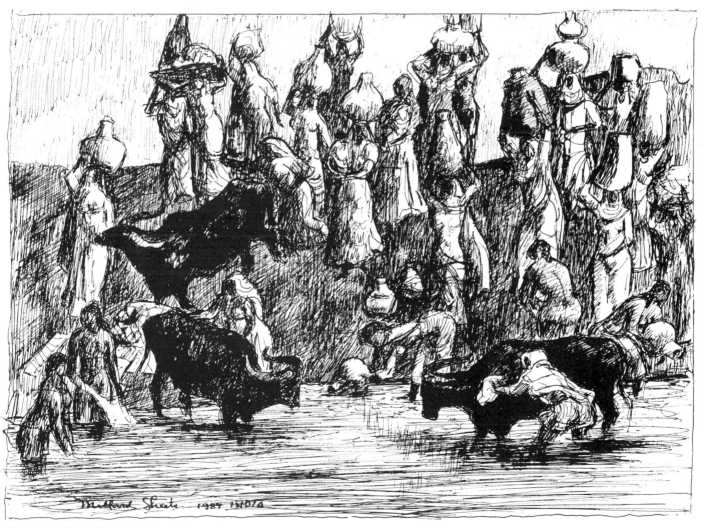

Ink drawing 7½" x 10" by Millard Sheets, N.A., A.W.S.

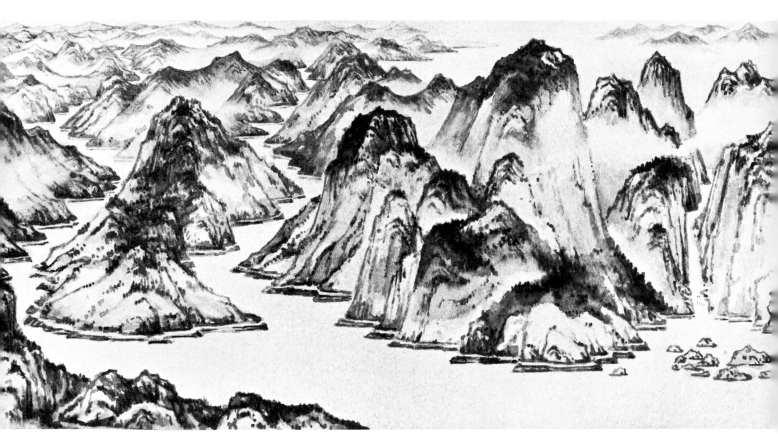

"PANORAMA-SICHUAN" drawing 18" x 38" by Diana Kan, A.N.A., A.W.S.

"Every good painting must be based on a good drawing.
Drawing is like the bones to the human body.
I do not use pencil to draw, instead, I draw directly with my brush as in this illustration titled "Panorama-Sichuan".

— DIANA KAN

Draw with your eyes. Enjoy the *discovery* of interesting shapes, the
thrill of discovering something new.

There's a difference between drawing to learn structure and gain information
and making a pattern for the design of a painting.

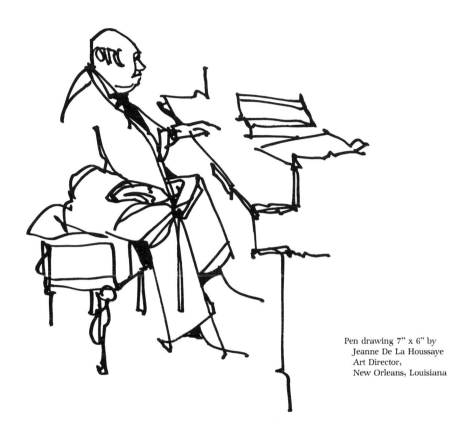

Pen drawing 7" x 6" by
Jeanne De La Houssaye
Art Director,
New Orleans, Louisiana

One day John Schaeffer was with his college students on the levee. He picked up a stick and quickly sketched with ink.

Ink drawing 4¾" x 8" by John Herbert Schaeffer A.I.A.

59

First gain the skill of drawing what you see. Try not to look at the paper. Concentrate on the subject. Look up and down quickly. The more you draw, the more your skill improves.

Even a painting that involves no drawing is based upon the acquired skill of drawing. When you drive a new car, you're overly cautious. You have trouble finding the ignition, getting used to the brakes. After you've driven it for a while it becomes *intuitive.* It should be the same with drawing.

Van Gogh said: Try to walk as much as you can, and keep your love for nature, for that is the true way to learn to understand art more and more. Painters understand nature and love her and teach us to see her. If one really loves nature, one can find beauty everywhere.

— in *Dear Theo*, ed. by Irving Stone.

These were drawn in the dark at a circus performance.

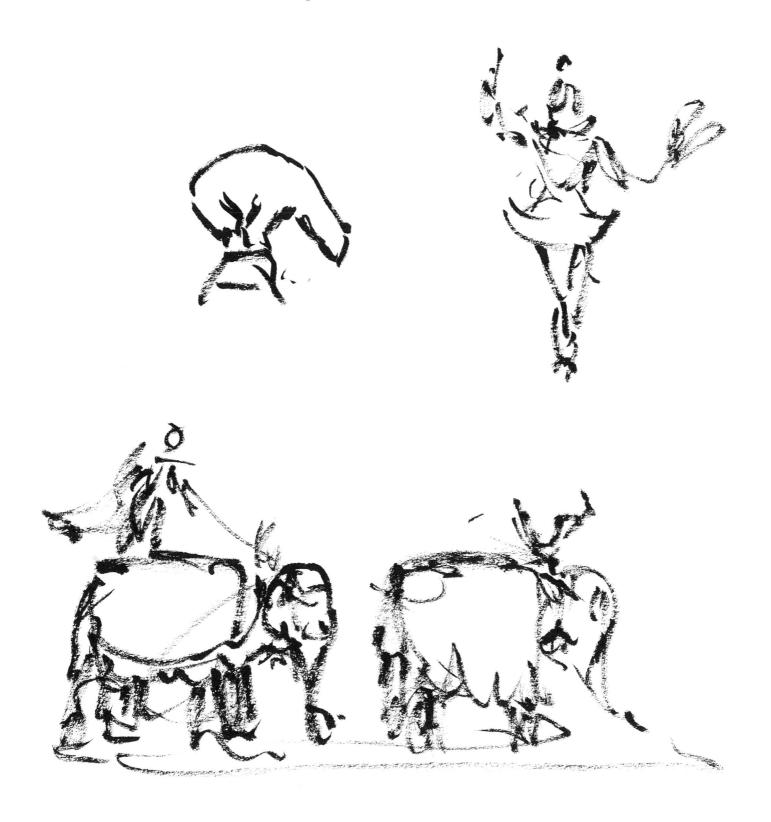

Ink brush drawings by Guy Lipscomb, S.W.A. (shown actual size)

"BALCONY AT HIGH TOR" Ink drawing 7" x 9" by Joan Irving, A.W.S., F.R.S.A.

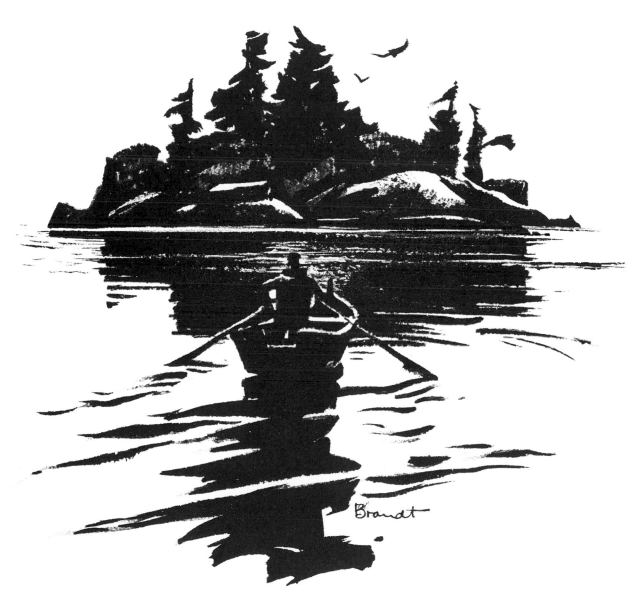

"FIGURE ROWING" India ink drybrush on Ingres Charcoal Paper 6½" x 7" by Rex Brandt, N.A., A.W.S.

I asked Rex Brandt if he had a sketch by Barse Miller that I could use. Rex sent a copy of it and he wrote to me about the drawing.

Pencil drawing 9" x 12" by Barse Miller, N.A., A.W.S. (1904-1973) Collection of Rex Brandt, N.A., A.W.S.

Colorado Aquaduct 1938

2-24-84

Dear Judi:

You should receive by now some odds & ends of dwgs. in which we enclosed a Xerox of one by Barse. dated 1938.

It's the only "pure" dwg. I have of his — two others are small sketch-studies for paintings.

Yes, I was with him when he did it —— or, rather he was with me:

I had done a portfolio of wfs for Fortune. 1937 on the building of the Metropolitan Aqueduct. They —— and the Water Dist. — wanted more: so in 1938 I was given carte blanche to paint anywhere along the 230 mile.

I took Joan down in the biggest tunnel —— under Mt. San Jacinto. 23 miles long. 2000 – 4000' under ground. Barse was so intrigued I took him there, too, on another trip.

← Mt. San Jacinto
12,000+'

Lawrence Adit — one of several access along the tunnel to speed digging

maybe 800'

o ← tunnel

(over)

66

"Man-train" along the tunnel carried us to the working face, where the drilling and blasting went on. Then we could exit up an <u>adit</u> — a sloped side tunnel to the face of the mt. This was on an inclined railway while we waited for the return

Barse sketched the hard-rock miner who was also waiting. His name was "Bill" as I remember. rather laconic — but you know Barse, he could get <u>anyone</u> to "sit" for him. Note Bill's Bull Durham tobacco tag hanging out of his pocket. The bell is on the train to signal when it's going to go.

Barse, of course, used no preliminary line. just a sure, steady contour line with some nice plays of space — non-space.

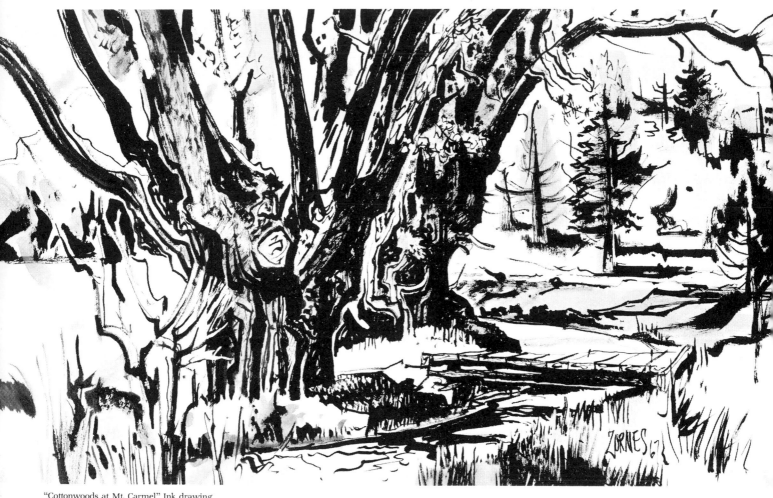

"Cottonwoods at Mt. Carmel" Ink drawing
by Milford Zornes, A.N.A., A.W.S.

There's a difference between drawing and making a pattern.

A pattern is the allocation of subject matter. If you choose something
in a landscape, like a piece of architecture,
where should it go on the paper?

upper left?

lower right?

how big should it be?

Patterning comes into play.

And design.

You can't design until you know how to draw.

Be aware of what Mondrian termed

"the law of dynamic equilibrium."

JUST AS RHYTHM shapes and structures music, making it comprehensible to the ear, compositional ordering gives life to painting. It is both the essential glue binding any painting and, frequently, the key ingredient distinguishing works of soaring visual poetry from mere daubing. As Pearl Buck aptly observed, "Order is the shape upon which beauty depends."

Of all the elements of compositional ordering, patterning is usually the least discussed. No artist can flourish without an innate sense of pattern, or what Mondrian termed "the law of dynamic equilibrium." Patterns of color, line or shape compose this equilibrium and create the visual cadence to which the viewer marches, strolls or waltzes—whether through a jazzy canvas by Stuart Davis, a painted architectural reverie by Charles Sheeler, or the dynamically extroverted rhythms of a Marsden Hartley abstraction.

It is only natural to associate highly patterened paintings with recent abstraction. The modernist urge toward two-dimensionality coincided perfectly with patterning's demand for a similarly spaceless ambience. This is not to suggest, however, that pattern entered the realms of art only during this century. The history of art is inconceivable without it.

— ARCHITECTURAL DIGEST
February 1984

Look at a quilt. The patterns and shapes and colors on a quilt can be
more exciting than a lot of paintings.

As we think about patterns, we think about order. Rex Brandt says there
are four patterns or designs:

cruciform (or t-shaped)

frame-in-frame (whirling, like John
Marin)

horizontal

vertical

we should

play with patterns as kids play in water.

Patterning without regard to subject matter is *nonobjective.*

If you have a landscape in mind, you'll think in
verticals and horizontals.

Chaos and disorientation — as when you get up in the morning and
the world spins — depends on diagonals.

Be aware of the space divisions — the horizontal — the vertical —
the structure.

Think about the point of interest, where you want the viewer to look, and
think about design principles. As we start to allocate,
where do we want the eye to go?

To direct the eye, use brighter colors, bigger shapes, smaller pieces.

Patterns are hard to talk about because once you've mastered them, it's
like something you've always known, like
how do you tell a child how to ride a bike . . . or water ski?

Dominant color — good shapes — rectangular
movement — vertical — static

Dominant color — and a little of the complement —
good shapes — squares — with variety —
checkerboard pattern with variety

Dominant color (different than #1)
good shapes — rectangular — movement
horizonal — dynamic

Dominant color — different than 1, 2, or 3
good shapes — oval (egg shaped but
with variety) movement — horizonal or vertical
static

The landscape painter can use the following variations, whether or not there is subject matter . . .

CURVILINEAR like a carnival or circus with a whirling feeling

the curves of the ferris wheels the merry-go-rounds

fat ladies sunglasses elephants' behinds

the wonder wheel duck shoots

clusters of animals cumbersome creatures

A flower garden is circles and part circles, or a curvilinear dominance.

DIAGONAL which is very difficult to use because it must be associated
with something
VERY DRAMATIC !!!!!!

like a sleet storm

or a w_re_{ck}

or athletics — like a ball

thrown

from

home

plate

to

second

base

If you want a feeling of quiet, don't use diagonals. If you want drama,
dynamic situations, use them.

Avoid the use of too many small pieces, or, as Barse Miller said,
"leave out the raisins."

On the other hand, using small pieces can give vibration, push and pull,
call attention to an area,
or give tension.

Here are some rectangular patterns: windows in a building
windows in a car doors, chimneys
shingles on a roof stripes on a shirt

legs on chairs.

All of these are hard to separate from subject matter.

If you play with colors and shapes and work with a quantity of small rectangles,
you'll find yourself pushing them around so that several pieces become one or
until chaos begins to happen.

Look at a skyline. Though it's a busy metropolitan area with hundreds
of rectangles, the more you work with it
the fewer you find you need.

How many rectangles does it take to make a skyline?

really just two . . . sky and buildings

If we add more, does it really help the composition?

It's instinctive to use many pieces.

But you can add drama or
call attention by using only a few specific shapes.

VII. Simple Shapes

We like a day when we don't have to do a whole lot, yet
 we get bored when we don't have anything to do.

We like simplicity, but not total emptiness.

Walk through a woods where nothing has been planned by mankind . . .

Sometimes we're bothered by weeds in a garden . . .

Monotony is *terrible:* something must happen to relieve boredom.

If you're driving along an interstate, every curve, incline, decline
 makes it more interesting.

We like simplicity, but we have to have a little variety.

Design sense is universal, even beyond the world of painting.
 cleaning up clutter, we feel better— a sink of dishes
 an office desk.
 Most people find tranquility in some order.

The simplest shapes can be the most striking, like
 an old Rolls Royce seen for the first time.

In some cultures, fewer adornments in a home are to be admired.

How few marks can you use to show the feeling of the ocean?
 steps or bricks in architecture?

You can make simple shapes by combining several creatures,
or moving things.

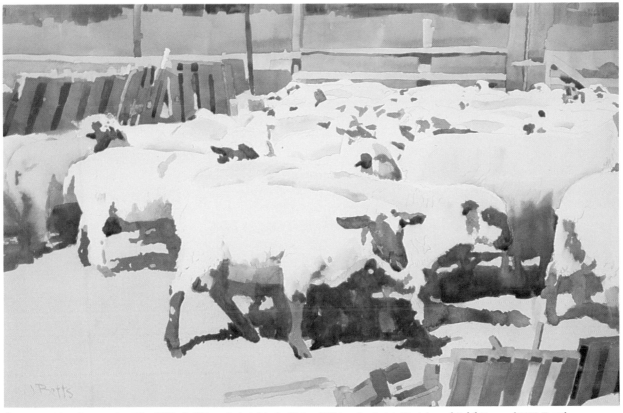

"EWE-ALL COME" watercolor 16" x 22" by Judi Betts, Included in the National Watercolor Society 62nd Annual Exhibition and 1983 Travel Exhibit — Laguna Beach, California; Aqueous Open '82 Pittsburgh Watercolor Society Award — Pittsburgh, Pennsylvania.

Simplify by making a mass of them,
 making a mass of their highlighted areas and shaded areas.

To get away from something is to see simplicity, as the patterns you see
from an airplane high above the earth.

The symbolism of these shapes arises in simplification. Making flags or
banners, you must cut out the felt, stitch and sew. Forced to use
simple shapes, you become more aware of the symbolism of your
work. Remember the cut paper we played with?

Patterns in the woods can be difficult, because people tend to think
too much of the different grasses, weeds, and trees.

Simple shapes are more effective than defining thousands of leaves.

POPE JOHN XXIII

*The older I grow, the more clearly I perceive the dignity and
winning beauty of simplicity in thought, conduct and speech;
a desire to simplify all that is complicated
and to treat everything with the greatest naturalness and clarity.*

"Simplify Your Life"
— MARTIN MARTY in *Reader's Digest*

The weight and value of a work of art depends wholly on its big simplicity.
— CHARLES HAWTHORNE.

The Big areas are harder than the details.

Nobody has trouble with details.

Did you read the small print?

If so, give yourself an A for this chapter.

"PALO ALTO SERIES — COWPER ST." watercolor 22" x 30" by Christopher Schink, Collection of Jane Jones, Dallas, Texas

I'm not really interested in the picturesque. I can find just as many painting possibilities in Palo Alto (where I live) as I can in Paris (although, admittedly, the restaurants in Paris *are* better).

While wandering around my neighborhood with my sketchbook in hand, I found an old white frame house with an interesting form and shadow pattern. In my painting I emphasized the abstract geometric qualities of the subject rather than the ornamental details.

I'm not very interested in the details of a subject. I find painting every weathered board and nail hole boring. What fascinates me are the shapes, patterns of light and dark and the color that I encounter out of doors.

My paintings are the result of careful editing. What you might see if you squinted at an old house in light and shadow and consciously ignored the picket fence and the flower pots on the window sill. I try to convey the feel and quality of a subject in the simplest possible terms.

— CHRISTOPHER SCHINK

VIII. Music and Art

Have you seen
 lived
experienced

 a toe-tapping painting lately?

one that stays with you the way a TV commercial does?
 A Sousa march?

 music and art have many things in common:
Timbre . . .

A violin and trumpet may play the same passage, the same note, the
same pitch, but they'll have different tone color.

 In painting, think about whether you're doing
 a piano part . . .
 a trumpet part . . .
 a violin part.

Duration of Tone . . .

 (How hard you press)

Get the right amount of paint and water on the end of the bristles.

Many painters make a bass drum mark when it should be a flute — or
march with boots when they should be doing ballet.

When I stand and paint I feel like an orchestra conductor. We both use our
 left hand for expressions and cues
 and the right to beat the rhythm.

 Conductors do all sorts of crazy things, though, and so do I.

When you paint, are you in charge of the orchestra?

can you bring in the bassoons?

quiet the clarinets?

single out the tambourine?

Dynamics . . .

or loud and soft

How are the dynamics in your painting?

(I can't illustrate this because it must be felt)
Try to have subtle nuances.

I feel the relationship because I played clarinet and piano, and I
believe that if you've participated in one creative area, you can
understand others a little more easily.

Walter Pater said, "All art aspires to the condition of music."

And Van Gogh again,

"Why do I understand the musician better than the painter?
Why do I see better the living principle of his abstractions?"

And Aaron Copland,

"The arts in general help to give significance to life."

And Louis Kahn,

"The creation of art is not the fulfillment of a need but
the creation of a need. The world never needed
Beethoven's Fifth Symphony until he created it.
Now we could not live without it."

A non-painter looking at our paintings can wonder how we get
color chords, sounds, melody, rhythm
in a painting at the same time,
just as

a non-musician wonders how a composer can
create music for many instruments simultaneously.

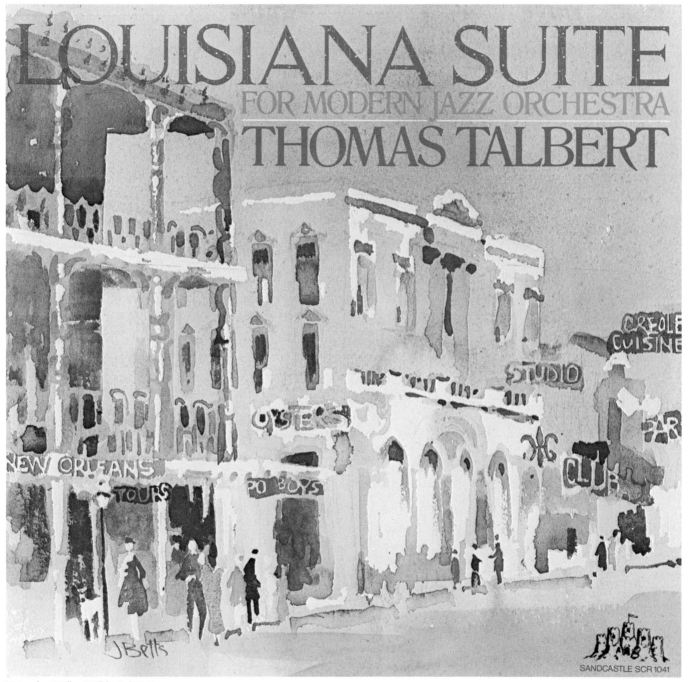

Watercolor 12½" x 12½" by Judi Betts
Collection of Thomas Talbert, Laguna Beach, California

More quotes:

The celebrated 'musicality' of Klee's art is one of the qualities that has most captivated the imagination of his public; it is one of the earliest themes in the Klee literature and is mentioned by almost all of his biographers and critics. During the 1950s, when appreciation of Klee's musicality was at its height, no fewer than six distinguished composers . . . produced musical works for which they claimed some form of direct inspiration from Klee's art.

— ANDREW KAGAN, in *Paul Klee, Art and Music.*

Take but degree away, untune that string,
And hark! what discord follows.

— SHAKESPEARE

Some paintings are out of tune, just a little bit — their strings aren't tuned.

Can you sing and dance a painting?

Can you hear your painting?

As you paint, can you hear a bass note when
you put it in? Is it on pitch?

We wonder sometimes about some painters, if they have magical brushes, or if
their tubes of paint are different.

One last quote, from the violinist teacher Shin'ichi Suzuki:

"Strings are mindless

They only sing forth the heart

Of those who ring them out."

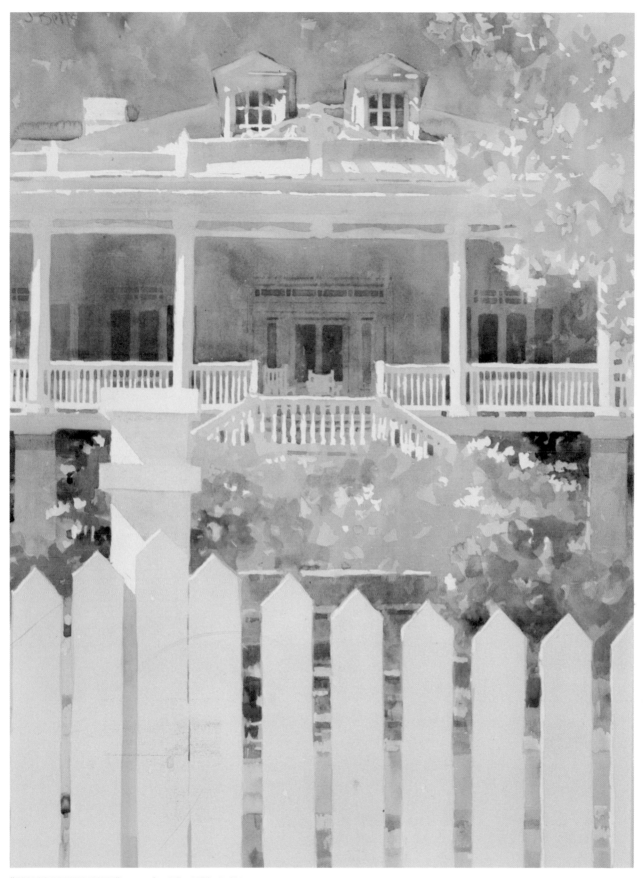

"CONFEDERATE MONEY" watercolor 30" x 22" by Judi Betts,
Collection of E. Gene Crain, Newport Beach, California.

IX. Paint Quality

Paint quality is a very important — yet at the same time a very small — part of the whole act of painting.

I can't teach paint quality; as with drawing, understanding arises only as the result of a tremendous amount of experience.

An advanced painter looking back will find changes due to the experience of the years.

Paint quality in painting is like the way a piano player touches the keys.

If you're doing watercolor, it's the amount of paint and water

the mixture on the brush

the way it's applied.

It's what makes a forever painting as opposed to just a painting.

I often get excited over my first wash on a painting,

by the transparency of the wash,

the look of a veil,

the feeling that I'm looking through beautiful colored glass,

like fog.

Plus at the same time, I'm excited by the color change through an area,

by its musical quality,

by the beautiful sound that happens to be a piece of paint,

like a passage of music.

"What did you mix to get that?" someone asks.

I really can't say, "I've been practicing for forty years."

Sometimes it's a nervous quality of the brush. Barse Miller literally
made a sound with the brush when he painted as a way of fusing paint
and paper. I could hear his brush. The experienced viewer can look at a
piece of a Miller and another painting and immediately identify it
— by its paint quality.

In a nonobjective painting, if it has spectacular paint quality,
what else does it need?

The difference between a prizewinner and a reject can be paint quality.
It can't be taught. It can only be learned as a result of lots of painting.

Sometimes it can arise from a bodily gesture. Rex Brandt wears
rubber-soled shoes to grab the floor.

Go outside with some paint and water. Using two-inch
 squares, make hundreds of pieces of color. 100. 200. 500.

 Now pick the *four* that have beautiful paint quality.

 Go into the woods. Make yourself comfortable. Take your lunch
 with you; leave the pager and baby at home.

 Listen to the sounds.
 Look at the colors.
 Match them.

 How many colors are in the sky today?

When you're able to identify your *own* beautiful paint quality, you'll
 be better able to judge your own work when you paint.

Remember, probably no painting will have 100 percent outstanding paint quality.
 But the best will stand out like the bride at a wedding
 like the complexion of a happy teenager

 like the character of a parent's hands.

 Take a walk and look for the *quality* in nature or the environment.

X. Abstract Underpainting

If you work with abstract painting for a period of time, you may
come to think of it as a melody, a song, a piece of beautiful music.

An abstract painting refers to *nonobjectivity* of subject matter.

Instead of subject matter, the painting has structure —

horizontal dominance or

vertical or

curvilinear or

diagonal —

that gives it the *feeling*

of chaos or

of quietness, like a lullaby, or

of the warm sun of your body on a pleasant day.

Try painting each of these: cool colors

warm colors

bright colors

gray.

In each of the above, try leaving some of the paper white, and
keep the paint no darker than a light midtone.

Then try with some areas of dark midtones but no darks.

Then, if you wish — IF YOU WISH — you can put subject matter into it.

You should be able to hear an underpainting or even smell it
as you feel a temperature.

Don't base subject matter on what you see in your abstract.

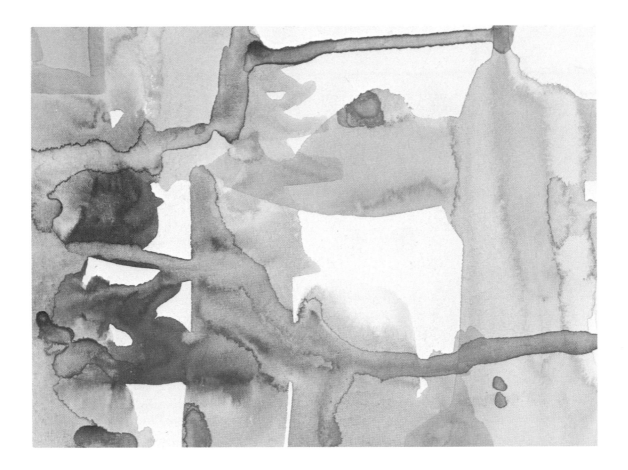

Rather, emphasize in your own mind the *emotional* aspect.

Does it feel like New York City on New Year's Eve?

or Key West in summer?

Does it smell like the inside of a Thai restaurant?

Perhaps you were in a shipyard when you painted this underpainting.

Does it smell like diesel fuel?

Take some time, a week, a month, and do 500 underpaintings.

Pick five that just feel good to you, so good that you don't
want to do anything else.

Pick five you enjoy and relate to, that intrigue you so that
you want to work subject matter into them.

Turn them around: make the verticals horizontal and the horizontals vertical.

Refer to your sketchbook. Make a drawing right on the underpainting.

Draw the FEELING of three men in a coal mine or
children at the beach.

Paint as though it were white paper. Let some show through.

React to it.

Cover up some of it.

Don't *worry* about the underpainting, just enjoy it.

Look at your underpaintings.

Can you find the best

piece of paint quality in each?

EMOTIONAL PAINTING

All painting should be emotional painting.

Emotions that have evolved from personal
experiences should be evident in a painter's work.

What separates a nice painting, one that's simply enjoyed by the viewer,
 from one that receives accolades (not just prizes)
 and possibly becomes a forever painting

 is the emotional involvement.

Rex Brandt says, "Emotion doesn't have to be happiness."

Think about

 pleasurable excitement

 disgust

 horror

 war

 ecological disaster, such as
 the tearing down of nature
 for an office building, or
 extremes in weather.

You should see emotional quality in a painting the way you
 hear fine tuning in an instrument.

Emotions can be summoned from *verbal* cues,

 from the memories of a story you heard as
 a child

 or replays of old radio programs

 hearing someone relate an adventure or close
 call with death.

Georgia O'Keeffe says she has memories that date from before she could walk.

Try to think back as far as you can. Are you really relying on things
 told to you?

Those memories — from verbal cues — can enrich your painting.

Emotions can be summoned through *sense experiences.*

I couldn't paint China, because I've never been there, but I could
 paint Hong Kong, seasickness, or the sound of milk being bottled.

I paint boats not only because my husband's work involves water,
but because of the importance of emotions
it brings out in me.

The smell of salt

dried fish

diesel fuel

wind.

The intense, almost unbearable heat

or cold.

The traumas of disaster, or the pleasures of

ship shapes

that give *joy* to a painting,

because of the variety of emotions I feel.

Paint what you know.

Ed Whitney says, "To paint a chicken you have to be a chicken."

To carve, sculpt, paint, or draw an animal,
you have to be that creature.

The older you become, the more information you acquire,
and the better you can use it.

Some painters enjoy growing their own flowers, just as some
cooks grow their own herbs or vegetables.

Joan Irving grows, cuts, and arranges the flowers for her paintings.

Be aware of sounds.

 If you're painting cattle, listen to the sounds not only

 of their hoofs, but

 the sound of their chewing,

 the sounds they make bumping fenceposts, buildings or each other.

 the cry of a cow that's lost a calf,

 the bellow when it's hungry,

 the snort when frightened,

 or the huff of breathing.

Feel their breath on your hand when you hold it out to them.

Feel their faces, the smooth parts, the hairy parts.

Know what a cow's ear feels like — like hard leather in some respects:

you can bend it, but it goes right back to its shape.

Have you been licked by a cow?

If so, you'll never forget the sandpaper feel.

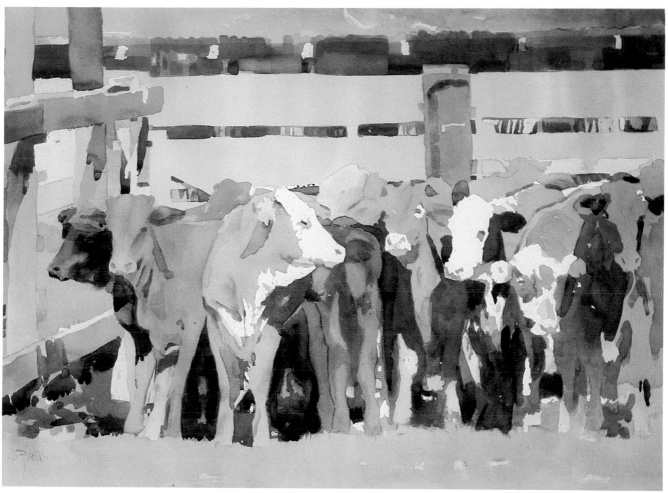

"PEN PALS" watercolor 22" x 30" by Judi Betts, Award, Western Federation of Watercolor Societies.
Collection of Mr. & Mrs. William E. Carl, Corpus Christi, Texas.

TACTILE SENSE

Can you touch it? Like foliage.

Someone not interested in plants might think they all feel the same.

They don't.

Some are limp.

Some have veins. Some are stiff.

Some are prickly.

Many have different sorts of edges.

If plants have this much variety,
you should be sensitive to it when
painting a landscape.

If we know it's there,
a little of the information may show up.

Learning and feeling emotional qualities is parallel to the way young
children taste carrots, or a spoon of spinach.

For a long time, *every* spoon of spinach will key the memory of the first, though
100 spoons of spinach can be 100 different tastes.

Writers, poets, dancers, musicians, and artists
are more emotional people.

When I visited John Marin's home, I felt I could

relate to his emotions,

feel his paintings.

When I looked at his paintings that involved the sea, I knew I'd been at
the same rocky coast where he'd worked.

Emotion

is sensitivity

to environment.

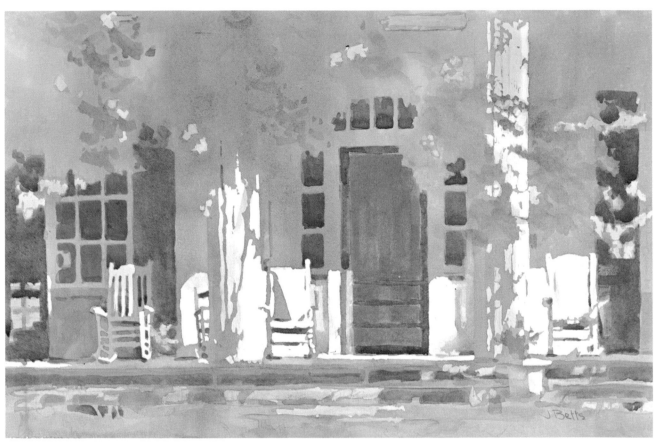

"ROCKIN' SUNDAY" watercolor 15" x 22" by Judi Betts, Award, San Diego Watercolor Society National Exhibition, 1979, Collection of Dr. John R. Clifford, Baton Rouge, Louisiana.

XI. At the End of a Painting . . .

1. Does it have three values?

 light midtone dark

 is one of them dominant?

It's *almost* impossible to have just three values because of gradations, but the light, midtone, and darks should read clearly.

2. Are there interesting white shapes?

these can be light shapes, too.

Ed Whitney says that interesting shapes have two qualities:

 they are oblique
 and interlocking

 do your light shapes relate to each other?

irrespective of your subject matter, are they interesting? Are they $M^AG^IC_A{}_L$?

3. Is there a center of interest?

or focal point

a place where the eye goes first.

It must be a dominant area,

or the eyes wander aimlessly through the painting.

4. Are there color changes?

there must be some, whether subtle
or DRAMATIC

and they should move across the painting, or

your audience will become uninterested and bored.

5. Is there gradation?

> gradation in size?
> in color and value?

> or are all your fenceposts the same size?

> Gradation gives strength to your dominant areas.

> Millard Sheets says, "Don't go an inch without changing color."

> Did you make something happen?

6. Can you "lift" some areas?

> Do you need contrast? Try going lighter. Take a clean, damp
> sponge and "scrub out" some of the color. It's a
> subtle correction.

Often it's better to make an area lighter, which makes the dark appear even darker.

7. Did you work as a sculptor today?

When I watch Doris White, the way she uses her hand, as she paints,

I feel as though
I'm watching a sculptor.

I don't deliberately think about fullness or roundness of a post or a cow.

I want it to be there, but it's

subconscious,

an awareness of the light and dark.

Chen Chi says use a round brush for fullness and fatness.

Create vibration, surface tension, so that even a two-dimensional piece of paper
feels like a sculptor's carving.

You can use overlapping,

like sailboats behind one another, a deck of cards effect.

Did you use your brush as a chisel?

8. Are you sensitive to "tilting"?

which is achieved by gradation.

The female form is of interest because of its subtle undulations.

A child with marbles will eventually find a tilted surface to make them roll.

Momentum creates excitement,

just as contrasts in a painting create fascination and entertainment on paper which is visually flat.

9. If you want it to appear flat, like cut paper,

are the shapes so simple that you could cut them out?

saw them if they were plywood?

Are there any unnecessary shapes?

Are there ways shapes might be combined?

Make sixteen little pieces into one simple shape.

Georgia O'Keeffe says you should simplify your painting as you might simplify your life.

10. Can you feel the way your subject smells?

If a painting is above ordinary, there will be the feeling

of aroma,

of temperature.

You can feel the sunshine, the warmth,

smell the flowers.

These feelings are intuitive, and they are emotional.

AFTERTHOUGHTS

A lot of people expect too much too soon. A person who takes golf lessons doesn't expect to play in the Masters the first year, yet a painter who studies watercolor expects to be super after three or four paintings. If one only does as Millard Sheets suggests and paints a "Color Chord" a day, it will take a long, long time to create a symphony.

Slow down. Don't expect too much of yourself too quickly. Success in painting requires a tremendous amount of hard work. — I've been at it for 40 years!

Don't be discouraged with yourself. Some painters can take giant steps right away; others will take small steps for a while and then giant steps later— if they continue to work at painting. Practice is as important in watercolor as in any other craft.

You will be rewarded for the work you put into it. As Ed Whitney says, in life, marriage, or business, you can be cheated; in art, you get what you earn.

Enjoy the challenge of learning
and the reward of progression.

Don't be disappointed by rejection.

Expect a miracle . . .

but a small one.

Be surprised — and honored - by anything else.